I write for poets who lost their tongues and forfeited their voices to the trauma they cannot express. For the black women who smother their own presence but are still just as beautiful. For the afros that don't bend at the whim of the conventional standards of beauty, for the Rasta men, for my parents, for love, for my friends.

I write for the 15-year-old black girl that occupied my body in 2015 and believed herself everything other than beautiful. I write for the lost, the found love, and most importantly the revolution. And I do this all while trying not to take life too seriously. Lastly, I write out of a passion for LOVE.

If life wasn't a joke, I would've swallowed my chuckles whole, developed them into tear-jerking sonnets, and fled ages ago.

Questions, reviews or concerns contact:

Instagram: @empressttree
Email: walkeralexis626@gmail.com

D1366409

CATTERPILLA

Adolescence

Fist full of afternoon, evening and way past curfew
I remember, skate nights and sunrise
youth hugged our knees
streetlights hugged the seams of my jeans
nobody could touch us

bikes, scooters and tris were our jobs
nature was our God
our families were our churches
sermon was our conversations
we were each other's street angels
nothing mattered
until one of us succumbed to the pavement
a little less poetically
reality peaked,
immunity voided

the world was spinning so fast and we couldn't even feel It

Lost/Realization

Am I not worthy
 Worthy of myself
 Of love
 Love doesn't find home in me
 Home Is where the heart is
 Is my
heart cold?

 My
 My
I have work to do.

Poetic blues

I wish there were enough stars in the sky
Then maybe God would be so kind as to shine the spotlight on
you

Here, see what angel I've made
This night, maybe happiness will finally cloud my insides
 Inside grief

has made a carcass of me
 Me only hollow
 Hollow does it sound when my heart sings
 Singing isn't

beautiful anymore without Jazz music, you and
me
Me and you were everything
 Everything feels a lot less like a Jazz tune

And more like the blues

3:00am Sabbath

I'm upset the sun rose today and forgot your gorgeous
How could she?
My soul drifts at night like a shallow lover overfilled with
longing
Doesn't she long for you as well
Sun rays use to brush against your melanin like *I love you*
Tell me,
Does God ever talk about me?
Like how we use to talk about him?
I mean it's only right, right?
Until next time

Following Monday evening:

Straddled my own tune,
I carried it to my mother and whispered her all my secrets:

I wish I was more beautiful,
Grief plummets my reality like an everlasting stain on my smile
Miles away is a heart that cringes at the thought of I
 I heard, Home is
where the heart lies and I feel homeless around nighttime
 when the darkness comes,
 and I can't feel my feet,
 I dangle them from the balcony of my dreams and wish they'd
take me away
 merely sweep me from my reality
 tumbleweed my identity

What is depression but a tainted dream
I'd wish I'd wake up
It follows my thoughts home,
tethers its fingertips to my brain and catches each wave and
throws it back to me
Here, take what's left of you

I smile,
Goodmorning everyone.

Realizations in the heart of a cancer:
I tend to love too harshly
Passionately stinging those who come across me
Numbness aches my body and strangled my bones when it
crosses me
I fathom not of being the puppet master of such thought, such
feeling
To love harshly is to love with meaning, to love to the core
To choke your heartstrings with mine just to remind you what it
feels like to be intertwined by someone

See, I dislike being alone on dark nights when I can't recognize
myself
Thought maybe
If I force myself into the window of your despair maybe, you'll
make room for me
Never exile she
See maybe she rocks with me like a cradle that never locks
She
I,
I wish I could love more gently

Maybe your window is locked
I tend to knock on it anyway
I hate being alone so maybe you do too
How selfish of I
To love harshly
Roughly

Untitled 2:00am

I'm way too good at goodbyes
and your presence isn't written in the stars because I've
prevented the universe from allowing you there
-insecurities

heART break

If I had one wish:
it would be that God summons up enough audacity to rough
draft the being of my second life morally ugly enough to despise
you
I jumped at your beckon call like a stray dog longing for
someone to belong to,
 only to be abandoned again in the end
I watercolored the ugly parts of you into denial as I watched
how beautiful your *Im sorrys* looked on the canvas that is my
body
you brushed kisses on me as if swallowing me whole would take
the place of apologies
you brush-stroked every inch of my being painting me too
beautiful to speak, perhaps
rock bottom is a brick tied at the bad of my foot and throwing
me into the abyss that was loving you

Painful Honesty

I often find myself more fascinated with ideas and love rather
than the people
whom they involve
I loved a man once who I never even loved at all
allowed my heart to fall two stories only to wake up with it still
in my chest
illusions are most prominent at rest as if I'm still trying to
convince myself of this feeling that will never exist for this being
I one night standed my emotions
Exploited my insides to you then ran from them
 I left you with nothing but the absence in my memory and
 words that pumped what could've been but will never be

Grief is killing me

Death is a mad woman
　　　　　　Women are supposed to beautiful
　　　　　　　　　　　　Beautiful was she from
a far

See I've lost a few homies, but death never crept into my home
and stole a soul directly from me
She was never bold like that

She lived here
And I lived there,
Cuddled up in a bed I've made while drunk off the idea of
immunity
I drank myself a tune at 16 then again at 18 then again at 19
That's when she made her move
　　　　　　　　　　　Moves were swift long and dreadful
　　　　　　　　　　　　　　　　Dreadful
is the one who feels the aftermath of her presence
　　　　　　　　　　　　　　Presence that wasn't
supposed to greet me
　　　　　　　Me and her had an agreement
　　　　　　　　　　　　Agreement signed in pinky
promises and heart-shaped prayers
　　　　　　　　　　Prayers couldn't even protect me
from grief
　　　Grief made me forget what it meant to be sad

　　　　　　　　　　How human is it to be surrounded by love
　　　　　　　　　　　How human is it to be robbed of such
　　　　　　　　　　　　And how human is it to feel grief?

I've seen rivers :
I've been black my last 5 lives
Suffering lingers in my veins as long as the Nile
I've seen rivers like Hughes
Held my breath and water flooded my shoes

I thought *America I* was too
Born a miseducated baby
They smiled me a lullaby then suffocated my tune
15, aborted *I too*
But formed my lips to say *me too*

I never fit in with the white girls
And the tone of my curl was ever so inviting
Accessibility looks a lot like black women regardless of the
lighting

I've seen rivers that look a lot like Saartiji Baartman
I've seen rivers that reflect from the sky and whisper me an
ancestral prayer at night
I've seen rivers that wrap themselves around wrist and pull me
back to me to Gods abyss when the world is crushing me
I've seen rivers
I've seen rivers too

I too' sing the blues of the black girl tune
Sew my voice into a jazz melody and sell the water in my shoes
I find myself swimming in the rivers that speak of Hughes

***Impatience and desire*:**
/my parents love Daniel Caesar /
/his aura floods the speakers in the form of love poems
accompanied with passionate melodies and I watch them dance
in awe, /
/partially wine drunk and fully in tune with one another /
/I watch, think, maybe, I /
/Maybe I do not worthy of a love such as this /
/like, you ever saw something so beautifully crafted, it seemed
unable to imitate? /
/love,
 maybe the height of your existence in a romantic sense doesn't
match the frequency of my consciousness and you're just not
feeling me yet /
/I mean at 18 I'd think I'd be ready to greet the peak of you with
open arms, but I recognize you deliver on the time of your
cupid, /
/although lousy and partially reckless in intentions, /
/you know what:
 love, where have you fled to? your presence is missed to those
who still acknowledge your true existence /
/although the down tone of your syllables doesn't play harp
with my heartstrings or demands me feel as it did anymore /
/your name, like a gateway to things less verbal, a fraudulent
attempt to belittling the depth of you
 or strike correlation with the density of my ocean as if deep is
only important within the discreet whispers of sheets/
/ my parents love Daniel Caesar /

Polygamous

I've created some of my best work under a night that doesn't
belong to me
Sneaking visits with the moon in my dreams in a desperate
attempt to find the God in me
Reflection is subjective,
I still see

She sang songs that treaded the cusp of my melodies daring me
to shed of my rationally,
feel then breed poetry-
the most irrational rational art form humans can muster
Exploring sins and exploiting blessings made under and at the
hands of her

I hushed her gone at dawn to greet the sun at the birth of him
Found myself kneeling at wake
but his presence couldn't demand the absence of my
vulnerability to subside under his light no matter how bright he
may appear
He shined several tones to see me,
he planted seeds of thinking logically
I couldn't help but think,
I'm two timing two gods
worshiping at convenient timing,
call me polygamous in this sense

Writer's Block:
My mind is in shackles,
wrapped in its own tune,
in its own words
own rhymes
caught sealed and in bondage in my mind
the trees still sway as your roar allows them to,
why don't you trust me with words as you use to
allow ebonic prefixes to snuggle their way before a Shakespeare
credited word
sneak in a suffix that may not fix but sounds gorgeous in poetic
language and conveys how I feel so I put it the universe
why have you robbed me of this
caught my mind slacking and robbed me of all, KRS-ONE
lectures, poems and last names of authors
all obsolete and no longer benefactors
it hurts,
question the poet or question their consistency
both horrid in thought
both cloud my mind
both I blame on you when I've lost mine
and I've started to belittle my expressions into I am fine
I can't write so my expression lack is at an all-time high
and I don't have enough height in my eyes to touch the sky
limits only set for those who dare go and I dare not face my fears
places I don't know

what is going on,
Is punishment really karma when it's self-inflicted?
maybe it's all an illusion and it's me who did this
constipated my mind into nothing less nonetheless maybe it's I
writer's block only an illusion just a scapegoat
just another excuse to explain why my words no longer beautiful
due to external wars interfering with internal forces

maybe that's what it is truly and utterly
but lately I've been on edge caught my myself stuttering using
curse words to cloud the flaw in my vocabulary and I just feel
less of me
less of myself I mean without knowledge of words do you really
know yourself
describing ones being is difficult with no adjectives to support
words are a part of me,
words make up who I am who I will be,
words are the beginning and end words help convey what's
within

Fallen,
I've found my chakras starved
Perception cloudy,
spiritually has my heart
but to commitment I'm lousy
I've fallen knee-deep in depression
God have you looked for me?
I've mastered every lesson
but I always end up on my knees
My ancestors love me
But my rituals lacked consistency
Tell me if they know of depression?
God can you hear me?

Generational Rage

Anger bubbles in the bellows bellow

I wonder where all this rage comes from

I was born holding a corpse on my shoulders that wore this skin
like a shining banner
2 stars away from their next birthday
cowards stripped their stripes
lynched their rights
and forced God to his knees
left their voice hanging on the last "I can 't breathes"
How do I still smile
When my ancestors are screaming?

I can't seem to shake the shakes at 19 and I feel empty

To be black is poetic
To be black in America is an ongoing eulogy
Names scattered profusely
Every one of them starts with a hanging prefix of
#blacklivesmatter
And ends with Amen

I wonder where all this rage comes from

COCOON

Hope clings to me,
 How often do birds cry
Does rain fall in suicide only to be reborn into new droplets
Will I fall into the bellow of rock bottom only to bloom like a
flower?

***Disconnection*:**

They say you feel lost before you find who you're supposed to
be

Spiritual awakenings feel a lot like sleeping and being thrown
about in your dreams
Focus and you will land in the arms of the higher being,
supposedly
My spiritual mentor never mentioned the reality of
disconnecting

Feeling like a stranger amongst familiar faces
Faces that were so kind to who you use to be
BE,
They don't even know they're standing in the presence of a body
that has forfeit her use to be
I,
Lost,
I,
Lonely
Lacking understanding prolonged my growth with a series of
social reconnecting
Reconnecting with energy that subjugates my frequency
Am I stupid?
Or merely human

Is it my ego?
She dislikes
Change

I long to be comfortable again
Call me nostalgic
Or a little less optimistic about
Change

See change wraps her arms around me and hugs me a squeeze
She touches me in ways that realign my spirit with who I am
supposed to be
Supposedly she knows what exactly she's doing

so, I swallow my tongue
Thank my gorgeous memories
Say goodbye to my old dreams
Occupants included and allow her to make every growing flow
of my being
disconnection

Self-love

How poetic is it to love and be loved simultaneously, endlessly and unconditionally... Find me.
-self love

15 Reasons why my favorite song is Suicidal Thoughts by biggie smalls:

1. Hear me out

2. His smooth dark humor creeped me a relatable story seeped into the exploitable parts of my teens and hugged me normal

3. I'd always found me to be anything but that

4. I found myself too in the plummeting abyss of my own misery before

5. *Cause I'm a piece of shit and it I ain't hard to fucking tell* was the soundtrack of my teens before black girls were cool,

before schools rang sensitive to the outcries of a dark face and a sad tune,

after I was told my depression was a disruptive elephant in the room,

 "Girl smile why don't you?!"

6. I*t don't make sense, goin' to heaven with the goodie-goodies, dressed* in perfection, I like having sex and drinking loosely

It's possible God would make an example out of my knees, when all of this is through

"What God do you bow too?"

"Must you rely on your own understanding here too?"

I reply: love you but sometimes I feel like I call but it never goes through

 and pleasure has never failed me

10. *God would really have me on some strict shit,*
 does freewill live in holy bliss or does that fade too with my earthly desires?
11. Philosophical in its essence, it coins many questions that resonate with my child like curiosity,
will I still be me in this floating utopia?
Liberated from which parts of I?
12. I don't want to go to hell, but heaven doesn't sound appealing to parts of me
13. I've never told anybody that part of my internal thoughts regarding happiness vs misery
14. *I swear to God sometimes I feel like death is fuckin' callin' me*
15. *I didn't think anybody would understand*

Uncomfortable

Twirl my tongue in an unfamiliar gasp
I can't breathe when I'm choking on my own thoughts
Suffocated by my ideologies
I feel more when nobody energy calls the bluff of the empath in
me
I must be growing

He found me

Jamaica is the first thing that attracted my reality to God
15, lost in puberty submerged in native sobriety
I knew not of the drunkenness of one's soul that resulted from
sadness
Or even love
Jamaica passed me grape juice and whispered me a love poem
*Here baby, address the God in you and see me as beautifully as I
ought to be*
Your reality is mean to be present here
*Here, love me as I have loved you with my beaches, patios and
swing of things*

Who knew a simple conversation with a Rasta man would save
my reality?
I glanced 3 times, in awe of his audacity
nappy dread, locked and loaded,
He spoke in syllables that bounces off my eardrums like an
ancestral drum
I know him
Not in a sense of remembrance but his heart swings at the same
pace as I

I,
Energy has never to me lied
Am I staring at my reflection in my eyes?
Lost, native and partially ignorant
it took me years to realize
Jamaica is the first thing that attracted my reality to God

Eye see

Eye see
I cease to view the world in tainted adjectives, far too gloomy
Far too Bluesy,
I found home in a music genre that looked a lot like my
grandfather
never bothered to question if I really liked Jazz music or if I
followed the downtown of its melodies home my grandfather
would come back to I
I, found happiness
I, found sadness in the crazies of my vulnerability but
The world is meant to be seen
So eye see
All 3

And sometimes I see him

Protection of I in a wounded world

Accessibility is a kind child
Her smile would drip down pride and wither it
She is acidic
She is native
She knows not of the damage

Do not touch the energy that floats around me
Texts included
Blocked, unfriended, existence muted
corrupted spirits need not taint the beauty of I
I am no longer a kind child
I'm 20 now.

Longing:
Truth,
I'm crazy about you
Literally crazed and somewhat obsessive over your essence I
I just wish an ancestor or two will blow my cover to you and
allow me access to ask the question of who actually are you
My apologies for making mortal of you but I can't comprehend
anything lacking human attributes,
reprogramming and such I've forgotten how
I think that's why I give God he like pronouns

What is truth?
Or does that term too fluctuate by human error
Subjective in its existence, circumstantial or bends at the whim
of whom accepts it

Possibly be it inbred,
and I have the answers, and everyone has lied to me
Possibly be it that ignorance is only bliss when ancestors are
muted

Possibly be it that hypotheticals wouldn't breed themselves in
the mind of an intellectual if truth would love me
Love me how love loves me,
and hope loves me and faith loves me
Truth always seems to be farther than arms reach
Needle in the haystack so to speak

Find me.

Energy lesson:

The law, keep your enemies closer than your friends is a hoax
A play on morals
A scoff at virtues
a submission to one's ego
A roaring laugh at the God in you

One keeps them closer to use them in ways that are beneficial
Why
Ego
Why

I found myself confronted with a series of why's from I
One cannot transform hateful energy under any God
Under any sky
One controls their reality
One is the observer and a reflection God within their soul resides

To keep those who harbor hate
Attempt to transform that hate if you may
To something possibly useful in the next days
Lays a tainted sheet over the energy exchange

We do this to ourselves and blame others
Do you not know of those that wish bad onto you?

Keeping them gives access,
They're keeping you close as well

Watercolor my gorgeous, title me happy,
color me grateful
wake me from my slumber and title you a dream
I've always been one to wear my heart on my sleeve
So,
color my body
Call her happy, riddle her beautiful
Hold her grace in your palm like love
Color me happy
Tell me I glow like the sunset that hugs my nappy
Nappy my root and greet my ancestry
Weave your fingertips through her identity and whisper her an offering
I'd always been the one to bear gifts artistically
Speak my language, color me
Color me
Color me black
Color me woman
Tell me my spirit dances with God on Saturdays only to rest on the Sabbath
Tell me how holy it is to still love when my trauma forsakes me
tell the child me, she is beautiful
Riddle her happy
Trauma free my chakras
Color me grateful

Philosophical questions at 4am

What's dope without the word or lips to speak it?
How dope are you when all the lights are cut off?
To be thought-provoking is a virtue,
but *no, really how dope are you?*
When your acrylics grow out, hairs fallen victim to your
pillowcases and your face is as naked as your body
- how appealing do you find yourself to be?

-God asked me one night, I shut my lights off
eyes shut, fell into the depths of my ego then climbed out free
To be a miseducated negro is to believe everything you're told
and everything you see

Epiphany: I didn't know who stood before me and knew only of
who I was told to be

How will I fit myself into an adjective I made up essentially?
We are all connected, so how on earth am I limiting my
excellence to something I embody without knowing?

smiles in black girl

Happiness rests in the roof of my mouth
Should I speak of her gorgeous, I'd say

This dimension with my physical vessel has had its way
I'm thankful to be black, though the world can be hateful
Everyday
365

Whole-time oneness and individual consciousness is
synonymous
I am you and you are me
Shed of this vessel
Open one's eye and see
The alternate reality
Of love and peace

I'm waking up now

Untitled

Flock your vowels to me
Clothe me in the consistency of your sentences
Need not be redundant with your tongue,
only repetitive
I want to feel every inch of your thought process

Fingertips speak a language far too vulgar
What's your favorite appetizer to summon your hunger?
Need I fit the category?
I'll allow your brain cells to feast on my heart strings until we
coexist in the same breath
I find myself losing mine when we speak,
please excuse me
I'm nervous,
emotions grab my tongue far too frequently
And exploit themselves far too loosely

It's just 11:00pm and I'm being choked by the verbs of those
meant to serve and protect me
How black of me?
How Booker T of me?
How MLK of I?
Spent all my time resting my vices on understanding
All for the same tongue to wrap around my existence like strange
fruit

Question All

But I am only a spirit vacating this body
Life Is far more than we are allowed to see
Freedom is everything
What does it mean when you don't even knows it for what it's
true definition ought to be?
How can I perceive something I've never seen?
I guess I'll just have to speak to the God in me.

Shedding of grudges

Clutter me not,
Defrost my ties with whom?
Surrender my guard where?
These are languages I speak not of

Clothe me in the hypotheticals and possibilities:
What if guards are a human thing
To truly grow is to embrace change
To embrace change is to be ok with non-human things
Like Agape

She crosses my mind from time to time
Divine in her existence
If I could describe her,
I'd call her black woman in white clothing with a side note
mentioning how godly of a sight that is

Carve me out and merely make beautiful of my (insides) poetry
Invite her to my signing
Laugh with the hypotheticals and good timing
Grudges are not a godly thing

Embrace those whom you cannot remember that wronged you
Smile in the absent of my memory
and defrost ties with whom

Sink or Swim

Depths of I
 I drown in them sometimes
 Sometimes I float

Ode to my throat chakra,

Ode to my throat chakra for yoking me up when I think I can
speak free of responsibilities
Ode to her womanhood
Ode to her femininity
Her stare that straightens me up how momma use too

Ode to my throat chakra for snatching me up when need be
she tells me to clean up before I can go outside
I summoned my demons murdered their existence within me,
greeted my kundalini and made home for her
Clean
I then went outside of my tonsils, scraped my knees leaving and
summoned up beautiful verbiage
My sentences played hopscotch in the sun while my verbs
danced
She smiled back at me as if she was proud and heard it

She once told me to pray more,
Make my tongue one with God
Dress my lips them in rosary beads so they dance on each *I love
you* divinely
I told her I don't believe
And she laughed
And kept laughing
And said stop lying to me

Ode to her love
Ode to her honesty
Ode to her respecting the introvert in me

I've never known a war more romantic than that to be
black in America,
Encrypted love letters smile from the forefront
I've never known a war more romantic

 Romantic is it to bear arms
 Romantic is it to be so in love

With freedom
You're willing to die
Ascend drenched in passion
I've never known a war more romantic
Then that of the black everyday experience
We flirt with or end beautifully
She loves us
And sometimes greets us early

Possibly be it the ancestors miss us more than others
Possibly be it we are loved

How romantic is that

BUTTAFLY

Ain't I a woman?

To be Woman,
 Ain't I?
 Lovely, Beautiful
 Beautiful must it be to Feel

Free
 Absent of Intersectionality and an influx of ideologies
unbeknownst to I
 I, only a flower, falling two steps from the tree
of my mother who always loved me gorgeous even when the
world croaked Ugly
 Ugly must It be to feel sometimes
 Sometimes aren't even
Enough
 Ain't I?

Buttafly

Held my breath and jumped

Evolution is not for the weak

I stare my reflection down
Who are you?

Clothed in I, smiles just like me
Brown frame accompanied ashy knees
I twerked to the cusp of my teens
Woke up drunkenly at twenty and I stare with she
Glare in palm,

Butta fly?

I've always made love with the idea of growth
I've always been her mistress
She'd always dipped her toe in my meditations only to remind
me how mythical her existence was
I knew nothing of the Buttafly
Cocoon my mind and call her I,
I was comfortable there
Staring at the everlasting glare of the identity I'd adored to wear

But where comfort reign growth withers
and I withered like a shallow stain
Stagnant

Cocoon my mind
Call me scared

Tether me to the safety net of my memory
Usher my soul there and never push her forward
Let her live in this nostalgia she speaks of

I danced on the brink of my comfort zone until my late teens
Butta fly waited for me at twenty
Nineteen I found myself in this mirror
of reflecting

L o c

Intertwine my soul with my hair follicles and call them mine
I knotted my insides and bred them with my out
Combed my fingertips through my skull and remembered who I
ought to be
Ode to royalty
Ode to the beautiful before the Eurocentric ideas of beauty
Robbed ancestral wealth that lied on the insides
revised and banished my crown before I'd gotten to inherit
Can I at least try it on first?

Maasai quake my insides and deliver me from myself
Reprogram my subconscious and return me to ancestral
wealth
My locs are I
And I am them

Gratitude

Life hugs my existence every morning
Greets my journey
Where some have been greeted with endings
that fall before dawn, and births mourning's
that ache a lot like back pains
and sorrow on busy weekdays with no relief
Where even good days feel like a broken soliloquy

Life wishes me a good night, every night
knight to my dreams, she wakes me
Rescue me from my screwed reality that subconsciously attacks
me in my dreams

Life lives

She has hugged me a little too tight
And oftentimes a little too loosely
But she's yet to fled

I live
In oneness
And individual consciousness

SMILE

Smile
Crooked teeth runny nose love is my favorite kind
The type that stabs at your falsified glorified ideologies of
something that cannot be limited to one way or one thing
or way of things

I first learned to love smiling
Gripping at my youth by my fingertips and dancing with my
twenties
I met a man who learned to love me
Understanding my complexity, he never forgets to smile at me
Full mouth,
tight face and all his energy forever broke my fall and I fell
On my face with my hands behind my back and a prayer in my
pocket
He never fails to impress me

When my voice breaks and emotions fall all around us
I fuss and hate, place on a stake and crucify ever vowel his lips
quake
He never forgets to smile at me
He must've learned how to love toughly
That by no means does love give up, see
He learned to love me under a sun that never failed to rise even
when we damned her
A moon that was full regardless of how many stars took a piece
of her light

My baby never loved selfishly
Loosely too loosely but never when it came to me
Directly, he always smiled directly at me

Possibly be that we both learned to love smiling
Before my roaring twenties tried to swallow me, before my teens
taught me, prior to my conceiving
Spirits smile too, see

Grudges don't live here

color my grudges beautiful and auction them to the sun
I tend to burn them there
Love waits for everyone,
So I forfeit the time limit of my ascension
I forgive freely and always at the time in which I need

Call me selfish or a little more self-loving
But I cannot help but hold my chest a little more tightly when
night falls and I'm not at peace

Color my gorgeous black
fill in my lines in woman, ask me why I forgot to love myself in
another
Ask me, what is it about my spirit or inbred thinking that causes
me to loathe those like me,
call it beefing,
as if we are not one in the same
Count my grudges, usher them into the sun, ase

Sign off my beautiful and remind me to erase the past like a love
letter to the future
Remind me of God

Remind me of love

Remind me that sista going through it too
Remind me that though we outgrew each other journeys love
always follows through

Remind me
Remind me
Remind me

That a grudge is nothing but an eternal force mocking the god in
you

Ascension

Fly baby girl fly
 Fly pass your past
 Past lives not in the soul of a butterfly
 Butterfly your existence
 Exist and never forget to live.
 Live and
don't look back

My love,
Whatchu thinking

Whatchu thinking

Whatchu think, King?

There will come a time in our lives when we will grow old
Sickly and hopeful
I'll kiss your worries from your age
When our backs start to break I'll steal every bone from your
misery and hush them a prayer
God. never let this man flee from me
Possibly be,
hypothetically he must leave
Allow him to wake me from my sleep and steal me too before I
can cry him a take me with you
We will run from this realm like a frightened child with so much
curiosity
With love all is possible
We will dance with our corpses at our feet and make love with
purely energy
I will love you a little more that day because with promised
eternity you'd never leave me.

Idol

Man, if I met Malcolm
I'd X every question linked to assigned bodies, configured
within the contents of the realities of those before them
I'd fall into the habit of asking questions linked to who he used
to be as if growth regardless of if I've read the biography still
finds itself connected by the root
I'd pride myself in defining the skeleton of my own and where
he can find her
And I'd snitch on every monument etched man

I'd snitch on every teacher who told me Christopher Columbus
was a hero,
I'd snitch on every American curriculum concerning the history
and write a letter about how I know that if everyone else but my
own
I will tell him where he can find my home
The inner Garvey in me refuses to believe America is the place
for me but I'm a hypocrite in continuing to sell myself to be a
means to society

I'd defend my actions by telling him the state in which we as a
people are in
I'd tell him I plan to be the heroine in this story, this reality

However, I'd rest my tangent and continue snitching
Concede I mention, every white man who took advantage of the motherland
How they'd thrusted their swords down her spine
then paralyzing her movements with chains, robbing her of her smile, and blatant enslavement, extermination and exploitation of her offspring

FOLLOW :

And I will follow you
Whether that means word meet tongue
Tongue meet mouth
mouth meet ears that may not bend in understanding
I will follow you
Through conflicting ideologies or my words refusing my
tongues audacity
I will follow you
Even if that means fire and brimstone breaks the bridge of my
tongue and strikes anger while Sodom and Gomorrah falls all
around us
I guess that's how the story ends and again I will follow
Whether sink or swim
or the Igbo dancing on the outskirts of my mind questioning my
courage to die for the sake of you
I will follow you
Even when they try to hang my voice like strange fruit,
I will dangle catty-corner
never falling far from the tree or landing far from the root-
Allowing Garvey to water parts of me while X kept my
grounded in identity
Allowing Martin to pray over me
I will swallow my cheek whole and renew its existence until
influenced

I'm so headstrong in ways
But still, I will follow you
Contingent on nothing but my devices,
I will follow until 1965 Bloody Sunday greets my sabbath and
leaves me on the pavement in the name of justice
And in the next life I will follow

And I will follow
And I will follow again.
My calling, my conscience, the voices in my head that do not
belong to me, thank you.

Black philosophers?

I was asked what a philosopher was in my African American philosophy class
I, 19, bright-eyed and native said, a black philosopher is just that

They say we don't exist
That the round of our lips carries an intellectual lisp
Call us only activists
Or merely intellectuals
Anything that curves the tongue of their desire
but not a philosopher,
 a term that never rested on the ideas of we

African dance is the one thing that never fled the memory of a colored body
provocative in its essence, clothe our bodies in our ancestors and
play a dope beat, twerking flooded my weak knees in familiarity
Rhythm may not live in every colored body but movement rest in our bones unapologetically
The ancestors' knew God would forgive our memory
So, they embedded theirs into our bodies

they'd bred each other's audacity and cake walked their happy
All in an expressive instrument that didn't belong to them
But they made theirs again,

We have a way of dancing around things that never belonged to
us to make them ours,
To take them Black

We dance around ideas less literally
so, I twerked with feminism

grinded with philosophy
I will paint the Cannon black and twerk me in, out and through
it until I feel like it
I made it mine,
I made it black
And that I am just that
A black philosopher
A black feminist

Emotional battle wounds,
some scars heal ugly
some wounds still sting
not all keloids' bore flowers,
not all battle scars hold proper bragging rights
not all healing starts beautifully
rough patches seem to rub against my progress inflaming far too
many breakdowns to break down to best friends when the
extrovert walks with her face down
 I tried to create beautiful things and they all bled self-pity
far too sad to breathe between similes
I wouldn't be able to catch my breath between trying to
memorize words describing this aging tomb within me
I feel dead sometimes
and other times I feel gorgeous
they don't really correlate but sometimes I'd rather be both
then sometimes
I wish I was one over the other then I backtrack to convos with
my mother when she'd talk about her mistakes and previous
hypotheticals and this time,
 I'd listen
make gospel of every vowel that fell off her tongue and live by
the word from a firsthand testimony
 and then maybe I wouldn't have allowed myself to run so
empty
let the life that happens for me happen to me and make me feel
more so hollow when I'm in my feelings

when I say not all healing starts beautiful,

I mean, flashbacks,
longs nights and anxiety attacks, are common,
tears like overdue finally breaking surface is not for no reason,
just hoarded emotions have been repressed and finally need
releasing
I'm saying it's ok not to be ok in moments, but ugly moments
shouldn't be defining ones
when I say not all healing starts beautiful,

I'm saying I love you and the journey ends beautifully.

Fallen. Gracefully
How? Glad you'd asked.

19, fell.
Made peace with it, didn't get up.
Didn't return to the world of generational hatred for anything
long term
I found youth and restlessness dripping from my lip like a leaky
faucet I forgot to tend to
Mend too, forgot times before and put an end to
Choice to ascend or fall victim to myself too
Generational curses, fail to effectively liberate oneself though we
pretend to

I almost tripped up a blessing embedded in the chart of I but I
just can't change, even on the flip side parallel universe
 I remain the same
I have Venus in cancer twelfth house,
AKA
Willingness to break down 12 walls, trial and error trip and falls,
ALL in the name of love signed off by a cancer poet who only
likes even numbers,

Tethered like two pinky's I promised you and I'll *see you again*
and remembered you our past life
Explained how your 1 couldn't be without my 2 due to how in
this world you see you and when coupled with you, I see us and
we both can't stand change pushed on us though still wise so we
compromised

Called your bluff and fell in love, heart absent of why's

I want nothing more than to tether my hands to your
heartstrings and harp you a beautiful melody while birds sing

*Like baby, do you hear how beautiful is only the sound of your
heartbeat?*
*Place your hand on my chest, can you feel your spirit dancing with
my heart strings through your fingertips?*
That's love

When a black father sleeps,
the weight of the world seems to have subsided,
each heave falls from his airways like a delivered prayer gracing
his peace while he floats in it
It's gorgeous really
As an adolescent observer in a sense in all aspects
My eyes use to swallow a lump sum and
I summoned up the interest to gather up my attention span to
watch as my father's eyes soften as if finally, there's no mission
No need to be a hero when civilization is tucked into the
security of their peace
Sleep was something my father didn't get enough of until our
heads fell victim to our pillows and our eyelids played jump rope
with each other until finally we laid to rest
I guess it's true you don't realize who the real hero is until your
exiled from their grasp and finally the real world thrusts its
existence at you and this time the excess weight falls and falls
hard
So now, when a black father rests...
I never take for granted their ability to be vulnerable, heroic
human and black

Open

Beautiful is the one who is an artist
 Art is the act of putting mind to the fingertip
 Tip me over and drown in my adjectives, here
take a piece of me

Thank you

Life is a gift I should've asked for
Life is a do over
Life is a standup comedy show in whole other state where
nothing matters but the bellows of your own laughter
Life will laugh with you and at you in the same breath
Life allows you to get the last laugh if you call her bluff:
Manifest your reality and smile enough

Life put itself at the palm of my hand and told me to run
Life is blatant, life is rebellious, life is that one drunk aunt that
talks a little too loosely:
life can be a distasteful comment, but it never really lies,

Life has lied me down in a room where everyone is standing,
Life's laughed at my vulnerability and demanded more,
Life promised me forever and I forgot my own mortality
life mocks, cocks back and drops bombs, life is risky
life

 is
 beautiful,
 life is
 beautiful,
 beautiful is life.
Life is love.

Dismantling of walls, acceptance of love:

Ok

Two syllables or a preamble for something great

Was the first thing I said when my heart let me pray

Ok

I'll let this one move mountains around me,

swallow me in every inch of him

This one need not anything of physicality but all from within I

I think I love him

Ok

Heart falls and stutter steps its way into my throat and I cough

him an *I love you*

Eyes gazing at the sky he whispers *I love you too* and I say

Ok

Lover,

thoughts arising surrounding my nonchalance are false

I'm speaking to myself when I say

Ok

Ok

I will let you love me

Ok

I will learn to love someone other than myself

 and to be a cancer is to know your heart is a glass bridge that

people always seem to fall through,

and it hurts

Pain lingers over here so you stray

Heartache hurts and I mean that in all physicality

I've had my chest submerge in a river I wasn't meant to float in

And I say ok only to hope me afloat with you

Ok

FLY

My parents watched me run track all my life
I, being the overthinker always questioned my hamstrings
One meet, father told me
Fly baby girl, fly
five syllables and four words
knocked on my eardrums,
made home in my subconscious and demanded to be felt with
no caution
promise to be evident with no consequences
 Consequences would only make a
mockery of its meaning

he told me to *Fly baby girl, fly*
I found sanctuary in places where thoughts never respected my
feelings
but in this apogee
My feelings bred with my thoughts
my thoughts consoled my heart
They all agreed in holy matrimony
and I was free

Fly baby girl, fly
I was always scared of heights
where they'd go
If I'd fall
Was the ground home?
Or was it simply a hold
 Hold on growth

Fly baby girl, fly
I smile at my thighs sometimes
And think,
It took me believing in you
For me to open my eyes

Fly baby girl, fly
I've flown
I'm still flying

Made in the USA
Coppell, TX
05 April 2021

53113055R10039